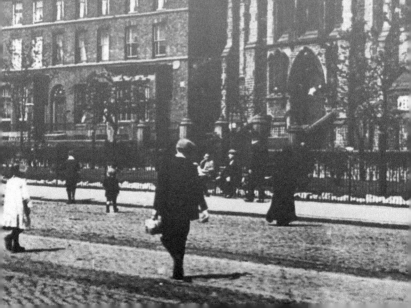

SALFORD
HISTORY TOUR

ACKNOWLEDGEMENTS

Most of the old photos were obtained from Salford Local History Library; the librarian Duncan McCormick was, as ever, unfailingly helpful. The new photos were taken by the author.

First published 2019

Amberley Publishing
The Hill, Stroud,
Gloucestershire, GL5 4EP
www.amberley-books.com

Copyright © Paul Hindle, 2019
Map contains Ordnance Survey data
© Crown copyright and database
right [2019]

The right of Paul Hindle to be
identified as the Author of this work
has been asserted in accordance with
the Copyrights, Designs and Patents
Act 1988.

ISBN 978 1 4456 9378 1 (print)
ISBN 978 1 4456 9379 8 (ebook)

British Library Cataloguing in
Publication Data.
A catalogue record for this book is
available from the British Library.

Origination by Amberley Publishing.
Printed in Great Britain.

INTRODUCTION

The first written record of Salford is in Domesday Book in 1086. It had a market by 1228 and obtained a borough charter in 1230. Sacred Trinity Church was founded in 1634. It was not until the late eighteenth century that urban growth began in earnest. This was largely enabled by improvements in transport: the River Irwell was made navigable from 1721, the first turnpikes (to Bolton, Duxbury, Wigan and Warrington) were created in 1753, the Bridgewater Canal was begun in 1759, the Manchester Bolton & Bury Canal was opened in 1797 and the Manchester to Bolton Railway was opened in 1838. Other notable dates were the openings of New Bailey Prison (1790), the first gasworks (1820), the Cross Street cattle market (1837), Peel Park (1846), the Roman Catholic Cathedral (1848), the free library and museum (1850), the first tramways (1877), Hope Hospital (1882), the Manchester Ship Canal and docks (1894) and the Technical Institute (1896). Salford became a parliamentary borough in 1832, a municipal borough in 1844, a county borough in 1889 and a city in 1926.

However, mid-nineteenth-century Salford was not a pleasant place; Engels, writing in 1845, described the town as 'unhealthy, dirty and dilapidated ... The whole of Salford consists of courts and lanes which are so narrow ... Salford is dirtier than Manchester ... I am sure that the narrow side streets and courts of Chapel Street, Greengate and Gravel Lane have never once been cleaned since they were built'. Ewan McColl's song summed it up neatly: 'I met my love by the gas works wall, dreamed a dream by the old canal, I kissed my girl by the factory wall, dirty old town, dirty old town.'

Salford's poor reputation lived on into the 1960s when large-scale redevelopment began, demolishing vast areas of slum housing and culminating in the development of Salford Quays.

Salford has often been overshadowed by its larger neighbour Manchester, but all three 'Manchester' racecourses were in Salford, as were 'Manchester' Exchange Station and most of 'Manchester' Docks. As far back as the 1790s the Manchester Bolton & Bury Canal began in Salford, not in Manchester. In the recent past the BBC kept announcing that it was moving to new premises in Manchester, rather than to the new Media City in Salford Quays.

This book starts in the historic centre of Salford, and then follows Chapel Street, the Crescent and Broad Street to Pendleton, with a diversion to Peel Park. The centre of Salford is already being extensively redeveloped with high-rise buildings, and they currently reach out as far as the Crescent. Future plans envisage this continuing along the A6 to encompass the university complex. The area is already starting to look very different, as can been seen in the photo below.

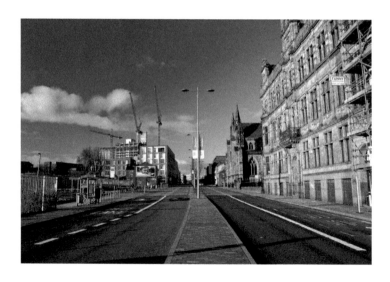

KEY

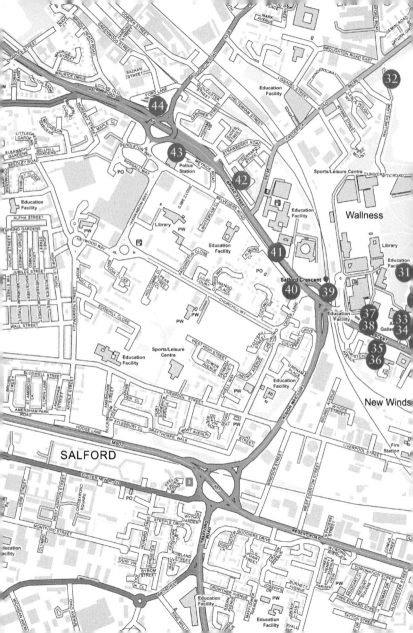

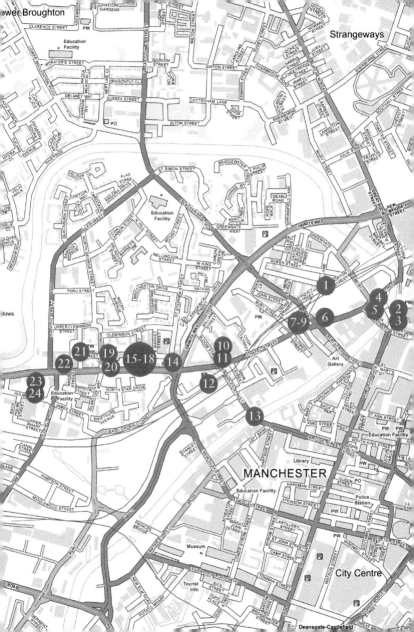

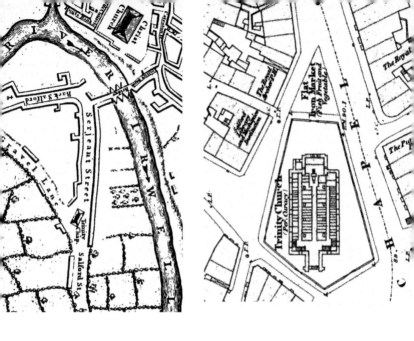

1. SALFORD MAPS

The map (above left) shows Salford in around 1650. It consists of a triangle of streets, focussing on Trinity Chapel, and a bridge crosses the River Irwell to Manchester and its prominent Christ Church.

The map (above right) is from the Ordnance Survey 5-foot plan surveyed in the mid-1840s, and shows Trinity Church (with its internal layout) and the Flat Iron Market (selling fish, fruit and vegetables), whose name is obvious from its shape.

The large map (opposite) was surveyed by William Green in 1787–93 and shows an enlarged town, though the built-up area, largely along Chapel Street, barely reached the Crescent. Three bridges connect Salford with Manchester, and the New Bayley Prison (opened in 1790) is an obvious feature.

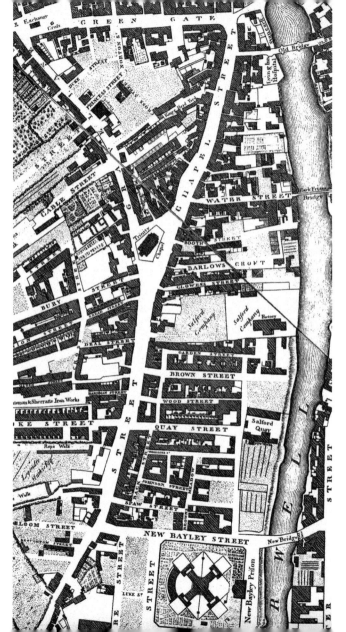

2. EXCHANGE STATION

The railway line linking Salford and Manchester Victoria stations was opened in 1844, but Victoria became so congested that Manchester Exchange station was opened by the LNWR in 1887, so-named even though most of it was in Salford. Manchester Cathedral is on the right of the picture, and a wide approach ramp led across the River Irwell to the station, now demolished and replaced by new developments.

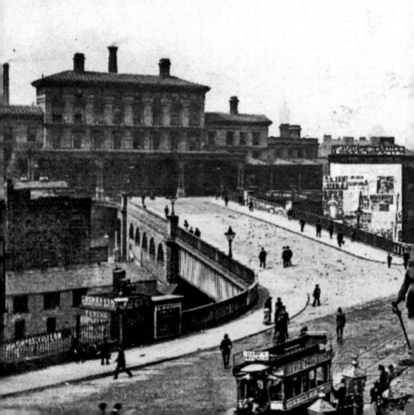

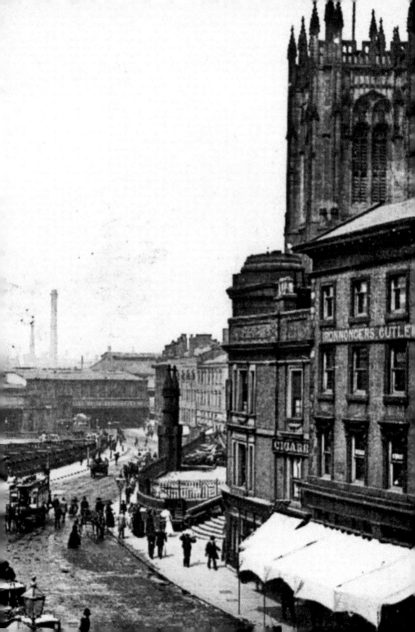

3. EXCHANGE STATION APPROACH

Something is clearly distracting the vendors in the picture. The sign indicates the great variety of destinations served by the station. From 1929 its platform 3 was linked to Victoria's platform 11 to create the longest platform in Europe, which was able to accommodate three trains. The station closed in 1969 and the site is now being redeveloped with high-rise buildings.

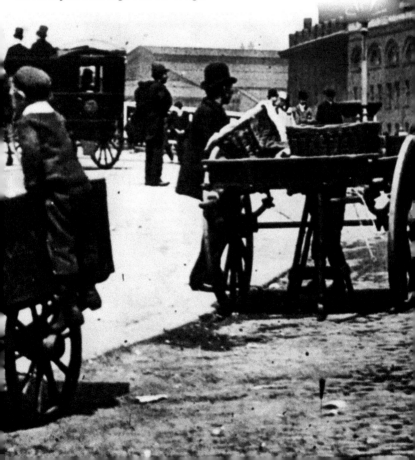

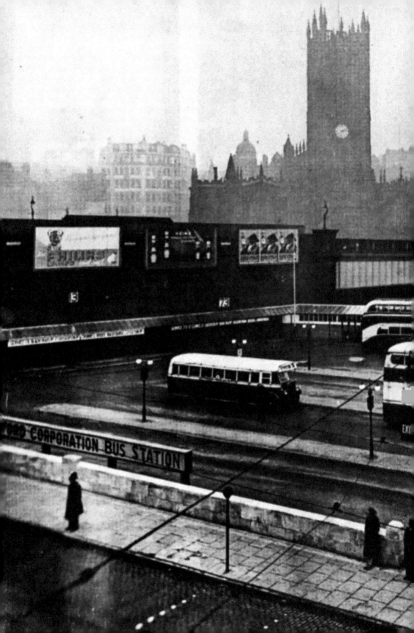

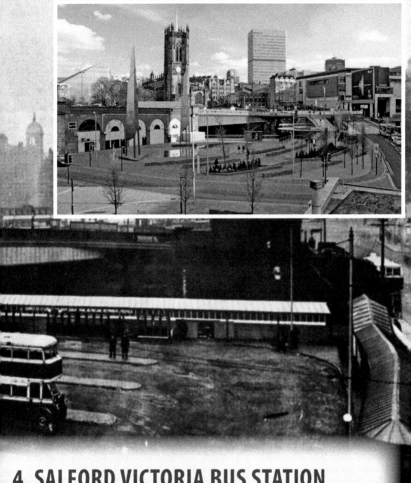

4. SALFORD VICTORIA BUS STATION

This area originally had industrial premises and a public house. The bus station was opened in 1937, and the picture was taken soon after. Manchester Cathedral looms behind. The bus station closed in 1988 and was for many years a car park. It is now an open area with a new footbridge across the River Irwell.

5. SALFORD VICTORIA BUS STATION AND CHAPEL STREET

The bus station site is now an open public space with a water feature, forming the first part of the Greengate Embankment regeneration area, which includes the former Exchange Station site and land beyond. Comparing the two pictures it is clear that few buildings have survived.

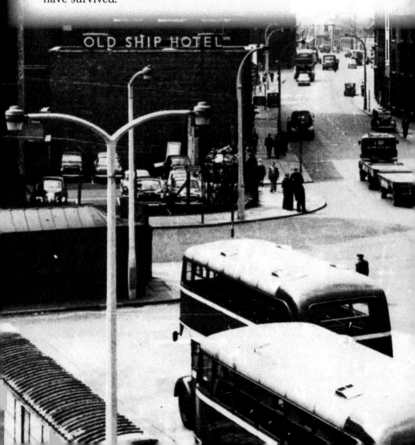

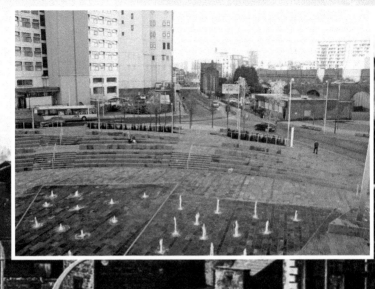

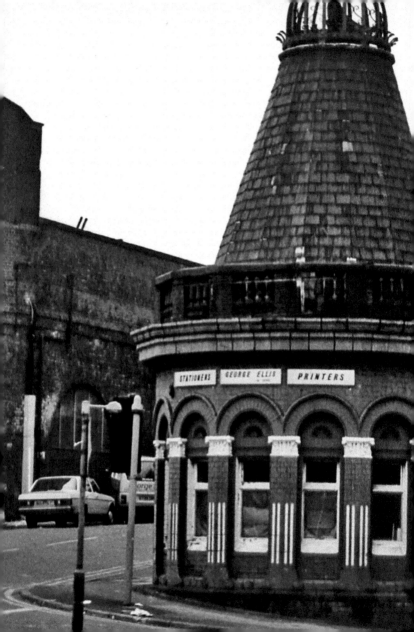

STATIONERS GEORGE ELLIS PRINTERS

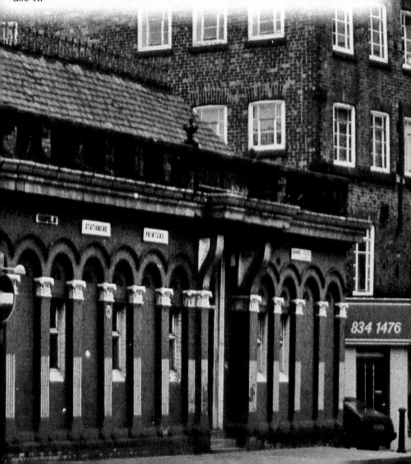

6. OLD POLICE STATION

The police station replaced an earlier one in Harding's Buildings, just behind, which was lost in the construction of the Salford approach ramp to Exchange station. This building was later used as a tram ticket office and then as part of a print works. Several firms now use it.

7. SACRED TRINITY CHURCH

Completed in 1635, this is Salford's oldest church. As a chapel it gave its name to the street. It was originally built with funds provided by Sir Humphrey Booth. It became an independent parish church in 1650, and John Wesley preached here in 1733. The church was rebuilt in 1752–53, restored in 1877, and altered internally in the 1980s.

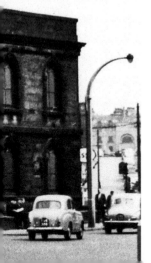

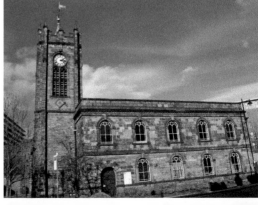

FLAT IRON MARKET

market was shown on the 1840s Ordnance Survey map as selling
, fruit and vegetables, though it later specialised in second-hand
ning and books. It got its name from the distinctive shape of the
(see map on page 8). The picture was taken in 1896. The market
ed here in 1939, and the stalls moved to Cross Lane Market.

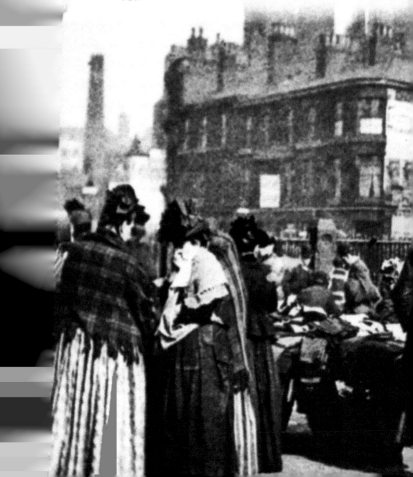

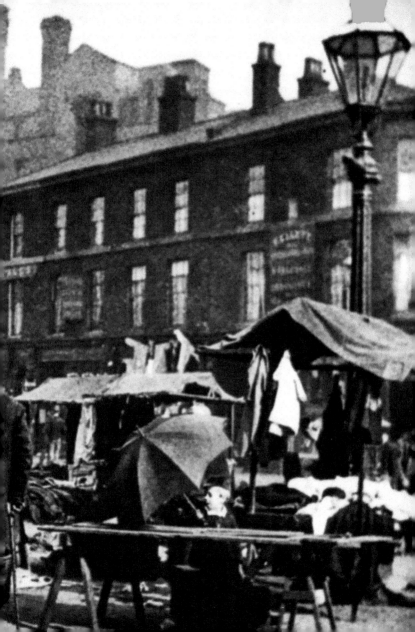

9. FLAT IRON MARKET

The market overflowed onto the space behind the church and is shown on the 1915 Ordnance Survey 25-inch map as 'Trinity Market'. The picture was taken in 1925. The Flat Iron conservation area includes the church, two public houses and two other buildings. It extends along the right-hand side of Blackfriars Street to the River Irwell.

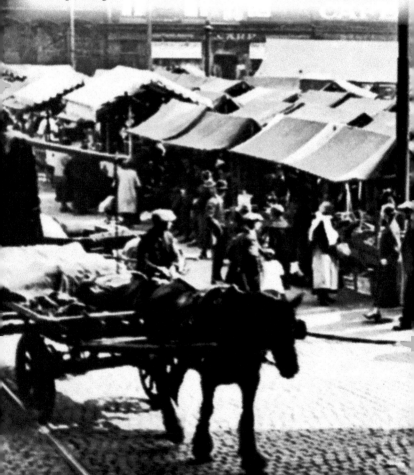

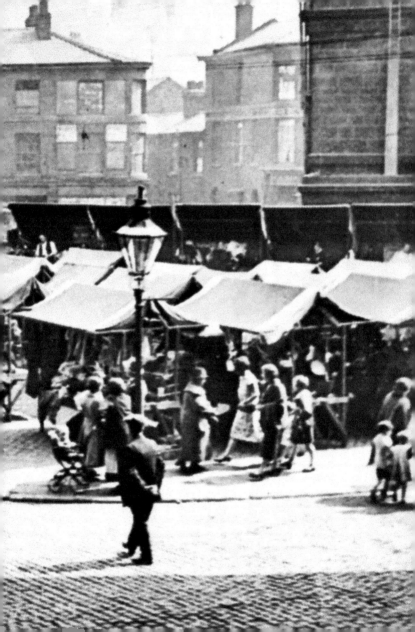

10. COOK STREET BREWERY

This impressive brewery was built by Threlfalls in 1896. It merged with Chesters in 1961, was taken over by Whitbread in 1967 and was closed in 1999. It was the largest brewery in the north-west of England. It has now been converted into an 'urban business village' called the Deva Centre.

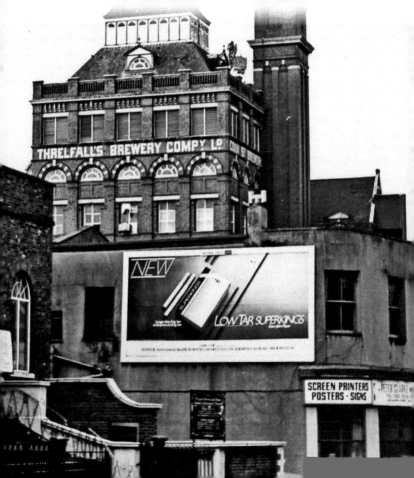

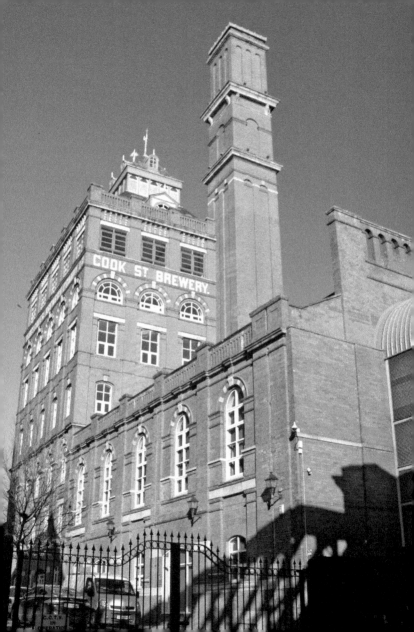

11. CHAPEL STREET CHAPEL

The Independent Congregational chapel was built in 1819, and this picture was taken in 1962. It is now called Chapel Street and Hope United Reformed Church.

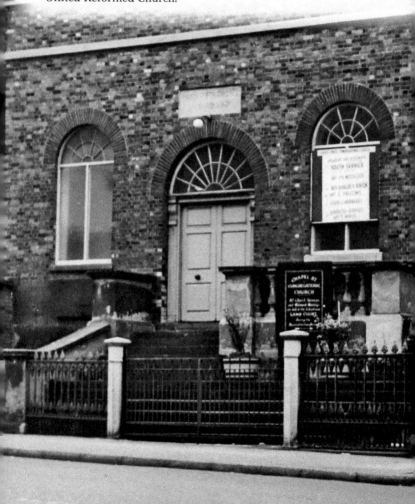

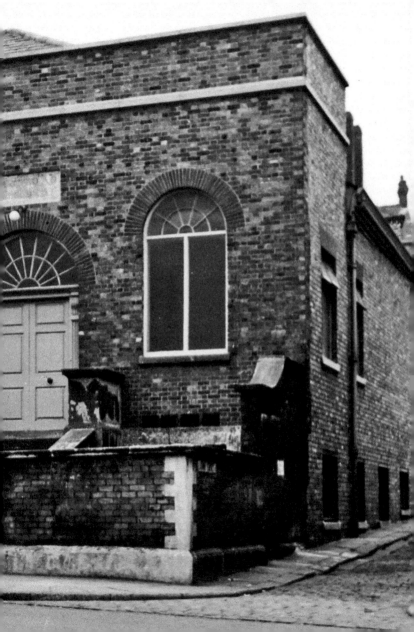

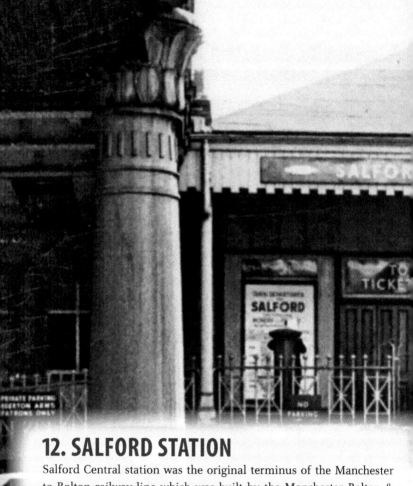

12. SALFORD STATION

Salford Central station was the original terminus of the Manchester to Bolton railway line which was built by the Manchester Bolton & Bury Canal and Railway and opened in 1838. The line was extended to Manchester Victoria in 1844. The three bridges that span New Bailey Street are all different, each with different style columns, and are listed structures. New Bailey Prison (1790–1860) formerly stood between the railway and the river.

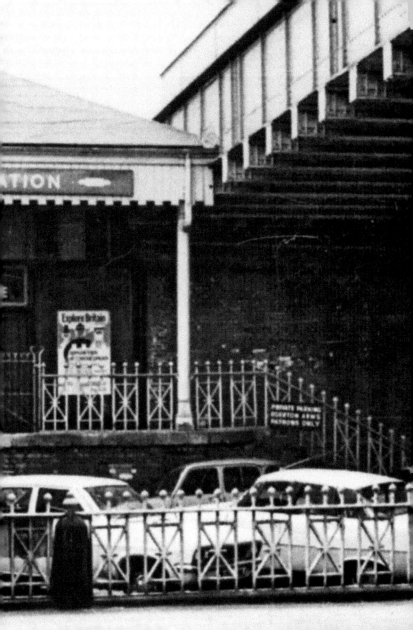

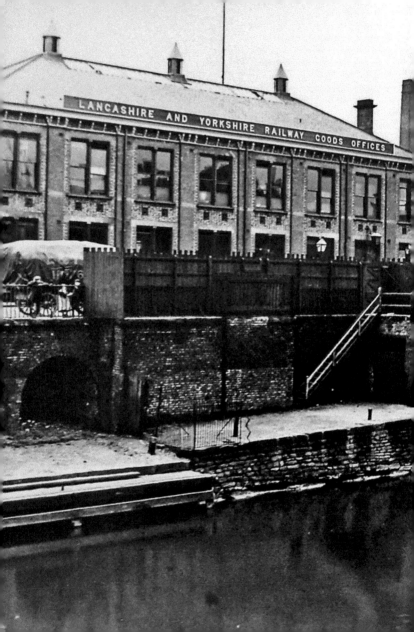

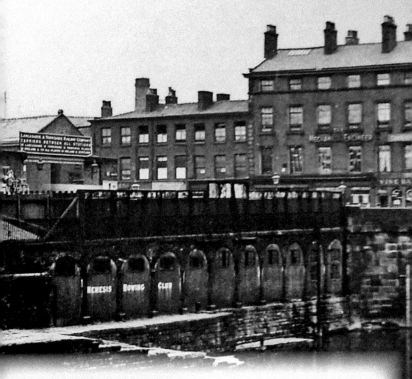

13. ALBERT BRIDGE

Albert Bridge was opened in 1844, connecting New Bailey Street to Bridge Street. The Lancashire & Yorkshire Railway goods offices have long since disappeared. The arches previously partly occupied by the Nemesis Rowing Club later became home to the now closed Mark Addy restaurant. Mark Addy (1838–90) was known as the 'Salford Hero' and was awarded the Victoria Cross for saving many people from drowning in the River Irwell.

14. SALFORD CINEMA

This was originally a Scottish Presbyterian church, built in 1846 with a tall spire. The spire was taken down and a new frontage added (including a Moorish cupola) in 1912 when it became the Salford Cinema. It became the Rex Cinema in 1933 but closed in 1959 and was then used as a bingo hall from 1967. The picture was taken in 1957. For over twenty years it has been the New Harvest multicultural church.

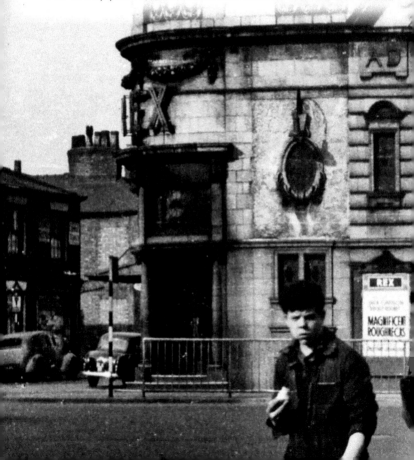

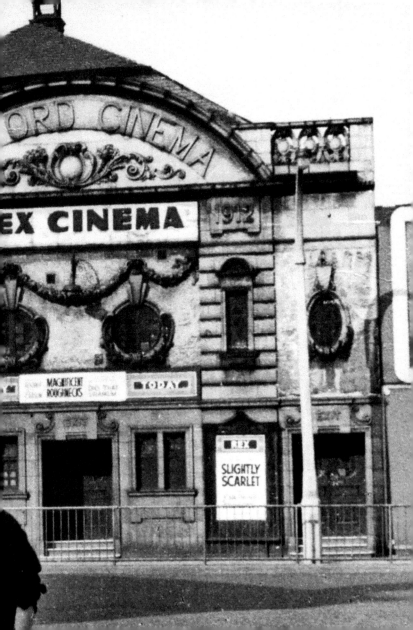

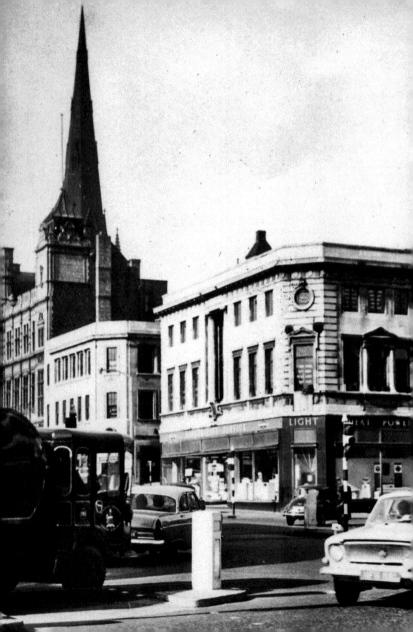

15. CHAPEL STREET

This picture was taken in 1963. Chapel Street has now been regenerated with a 20 mph speed limit, new street lighting and surfacing. It is now an attractive city high street connecting Salford University with Manchester city centre, with a mixture of housing, shops and businesses.

16. SALFORD TOWN HALL

The Town Hall was built in 1825–27, and stands in Bexley Square, named after Lord Bexley, then Lord Lieutenant of Lancashire. At first it had a market hall on the ground floor. It was the scene of the Battle of Bexley Square in 1931, a protest against means testing. The picture was taken in 1930. The building is now the city's magistrates' court.

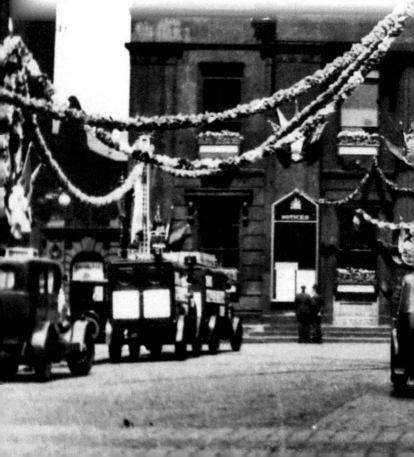

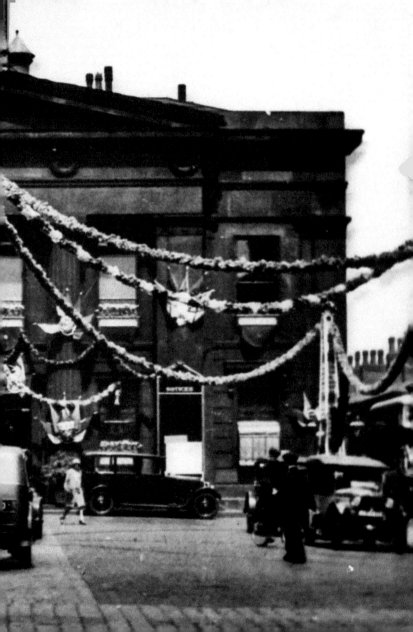

17. OXFORD HOTEL

The main picture shows the Oxford Hotel in the 1950s. It is now called the New Oxford, and frequently appears in the *Good Beer Guide*.

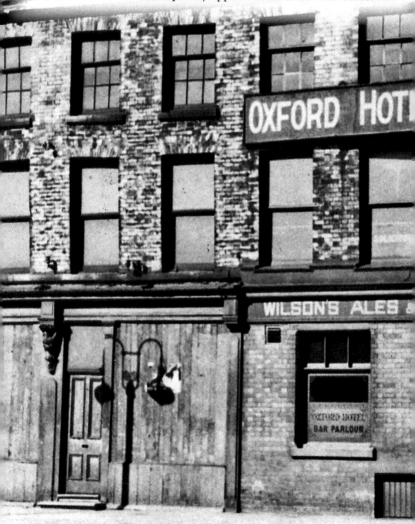

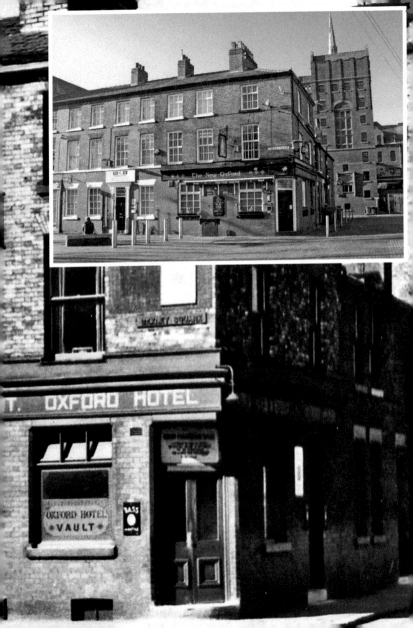

18. CHAPEL STREET

This picture shows the continuation of Chapel Street, which was the setting for Henry Hobson's shoe shop in Harold Brighouse's 1915 play *Hobson's Choice*. It was the principal road of the town for many years, seeing the first omnibus service in 1824, horse trams in 1877 and electric trams in 1901.

19. SALFORD CATHEDRAL

The foundation stone of St John's Cathedral was laid in 1844 and it was consecrated in 1848. It was designed by Matthew Hadfield and has many medieval-style elements, as well as the tallest spire in Salford. It was the first Roman Catholic church built in a cruciform shape since the Reformation. The picture on the left was taken in 1963, and the picture on the right shows the *Seed* sculpture by Nadrew McKeown installed in 2002.

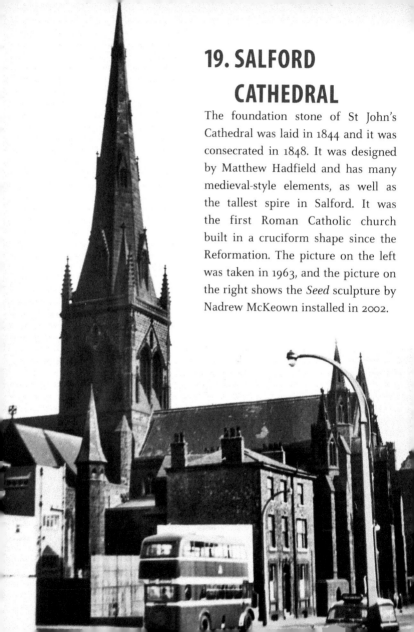

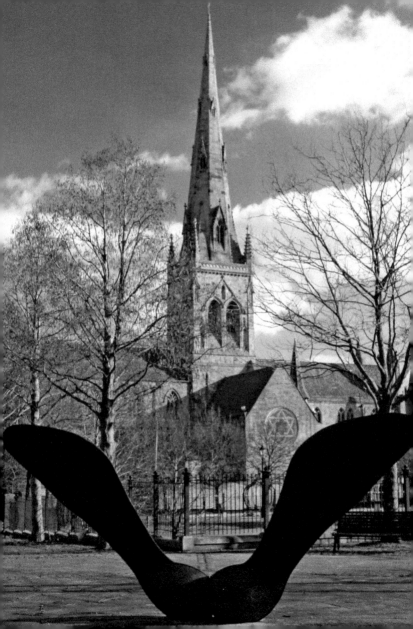

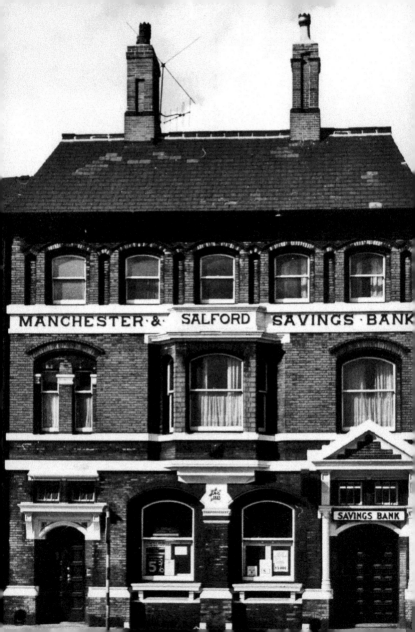

20. MANCHESTER & SALFORD SAVINGS BANK

The bank was established in 1818, and this branch was built in 1885.

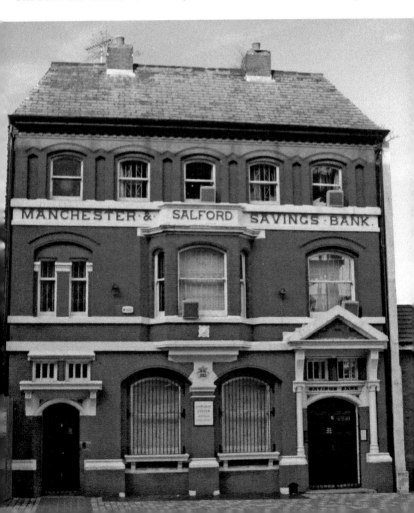

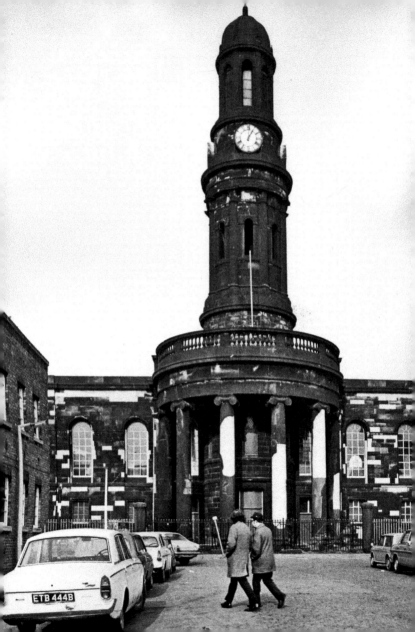

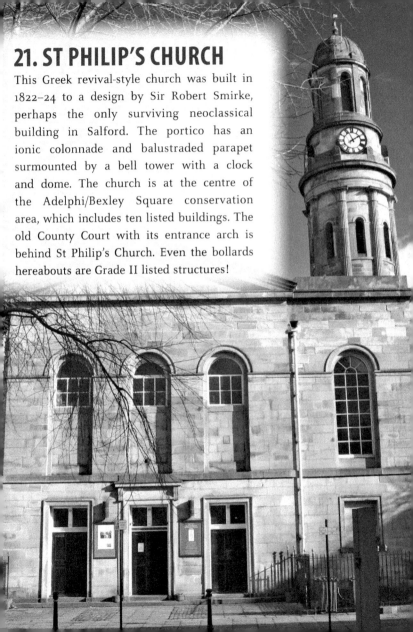

21. ST PHILIP'S CHURCH

This Greek revival-style church was built in 1822–24 to a design by Sir Robert Smirke, perhaps the only surviving neoclassical building in Salford. The portico has an ionic colonnade and balustraded parapet surmounted by a bell tower with a clock and dome. The church is at the centre of the Adelphi/Bexley Square conservation area, which includes ten listed buildings. The old County Court with its entrance arch is behind St Philip's Church. Even the bollards hereabouts are Grade II listed structures!

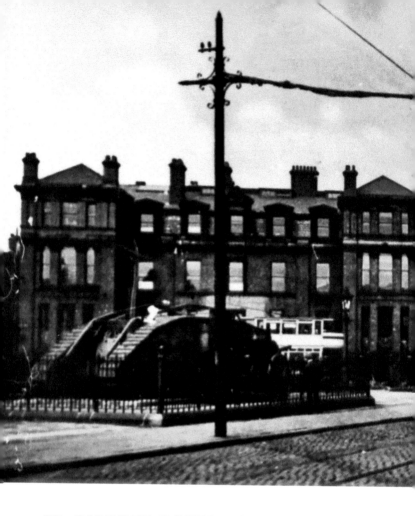

22. SALFORD ROYAL HOSPITAL

The Salford and Pendleton Dispensary opened here in 1827. It took its first inpatients in 1847 and added the word 'royal' to its title in 1847. By the 1870s it was known as Salford Royal Hospital, and the

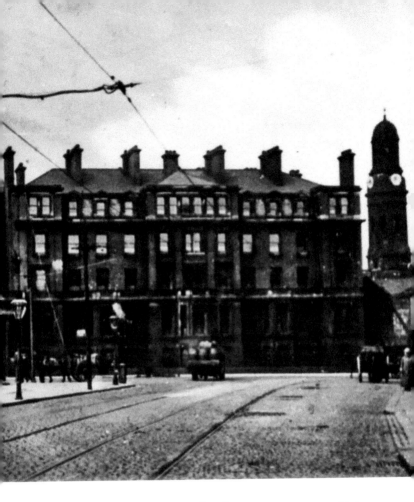

present building dates from 1896. It closed in 1993, was converted into apartments in 2002, and its name was transferred to Hope Hospital on Eccles Old Road.

23. THE CRESCENT

Salford Crescent overlooks a meander of the River Irwell and is famous for its row of Georgian terraced houses. Green's map of 1793 shows a few houses already built, and it was completely built

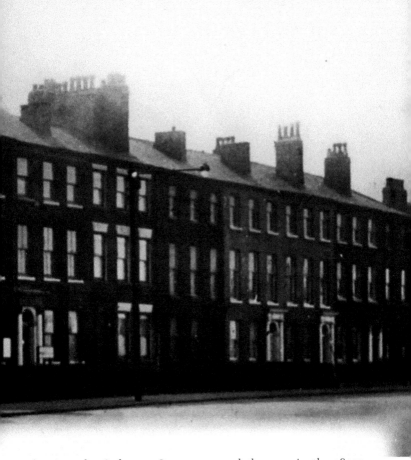

up by time the Ordnance Survey mapped the area in the 1840s. Several high-rise blocks are being built behind the terrace, and more are planned.

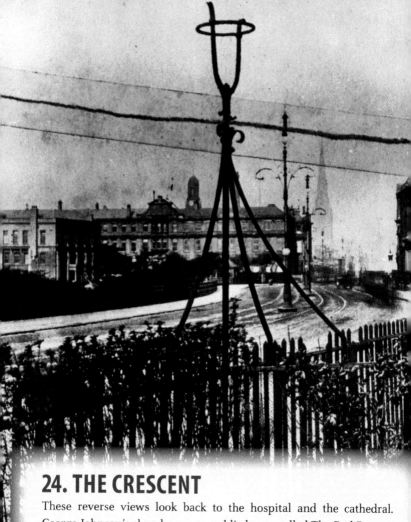

24. THE CRESCENT

These reverse views look back to the hospital and the cathedral. George Johnson's shop became a public house called The Red Dragon and was reputedly frequented by Frederick Engels and Karl Marx. It later became the Crescent pub, which was often included in the *Good Beer Guide*, used by locals and students alike. It is now closed.

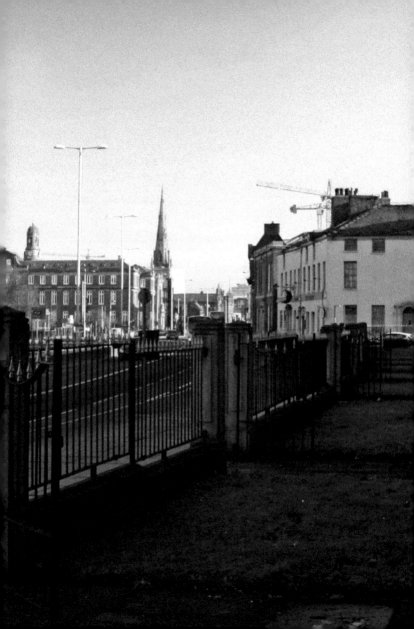

25. THE CRESCENT

The road in front of the houses is now the A6, and it was widened into a dual carriageway in the late 1960s. More recently it has had traffic-calming measures applied, including single-file traffic (plus a bus lane) and a 20 mph speed limit, which is good for pedestrians but less good for motorists.

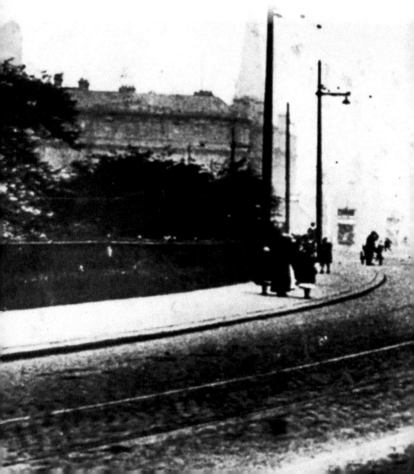

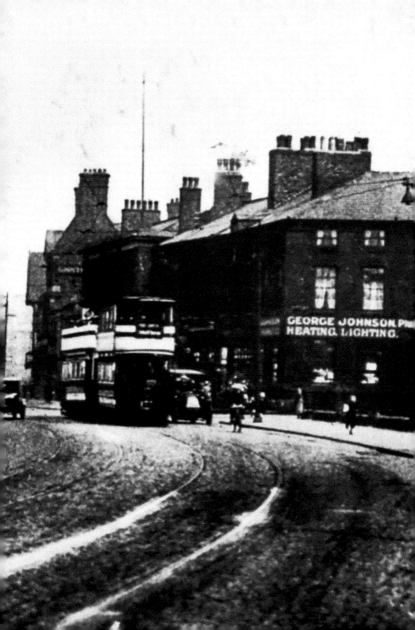

26. THE CRESCENT

Another view of the Crescent with the white Masonic Hall towards the left. Most of the other buildings were replaced by university buildings and the now boarded-up former police station.

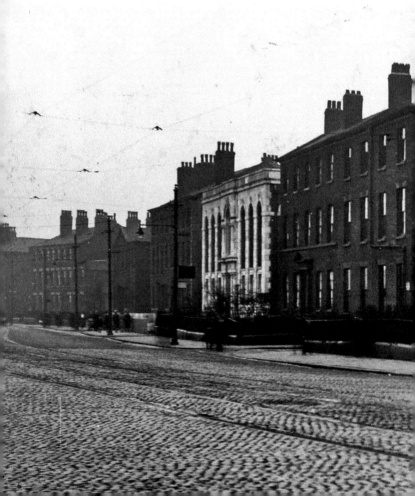

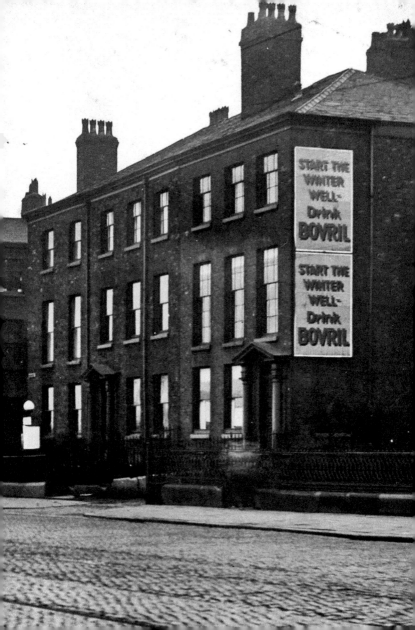

27. VICTORIA ARCH

The arch was erected in 1851 for the visit of Queen Victoria, and it formed the entrance to Peel Park and the museum and art gallery. It survived until 1937. The site is now one of the main entrances to the University of Salford. The university received its charter in 1967 with the Duke of Edinburgh as its first chancellor.

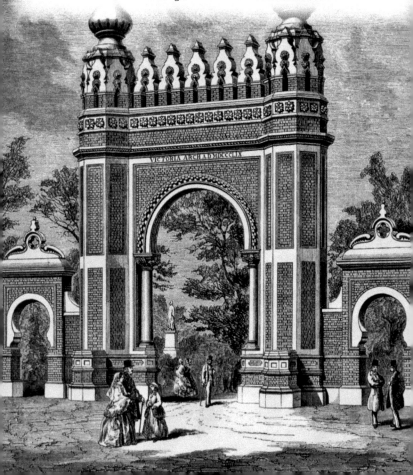

28. PEEL PARK

Peel Park was one of the first free public parks in Britain. Opened in 1846, it was named after Sir Robert Peel. The sundial that used to be here has gone, as have most of the recreational facilities.

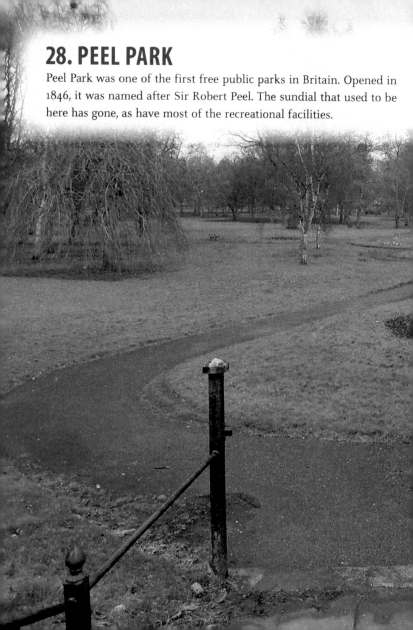

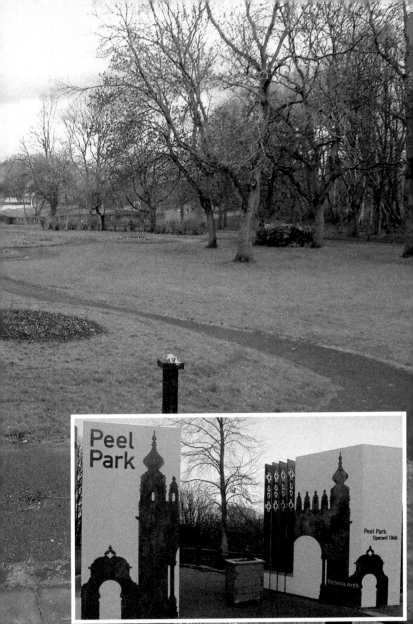

29. PEEL PARK

This picture was taken in 1913. The massive embankments to stop the River Irwell flooding the park are obvious.

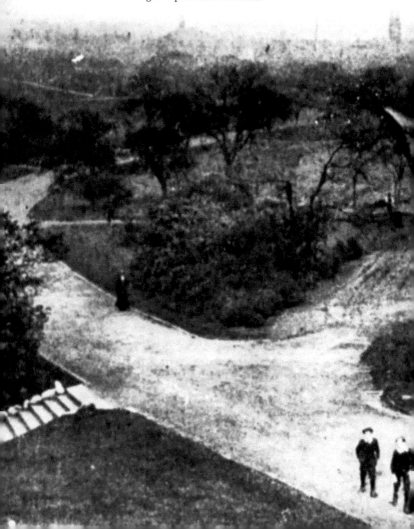

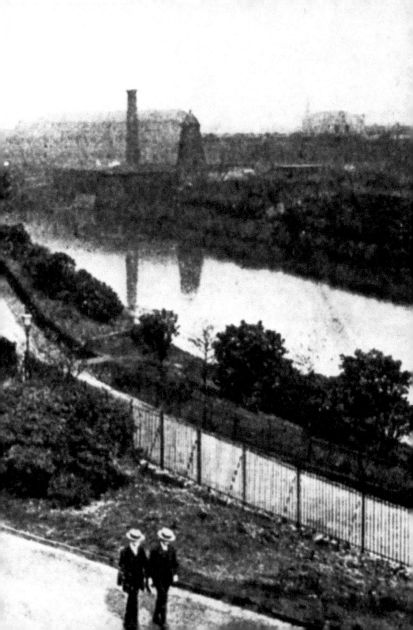

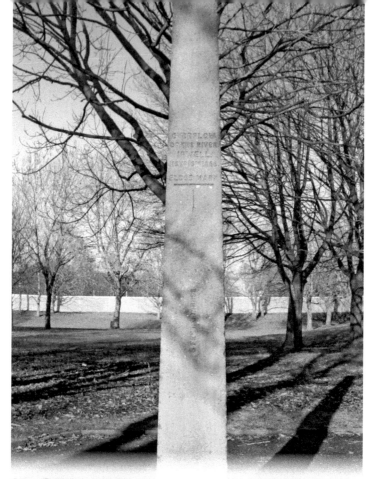

30. PEEL PARK

The obelisk marks a record flood in the park on 16 November 1866 when the water was 8 feet 6 inches deep. Large parts of Lower Broughton were also flooded and much damage was caused, and the river is now heavily embanked. The map (opposite) shows the park as it was in 1915, with glasshouses and various recreational facilities.

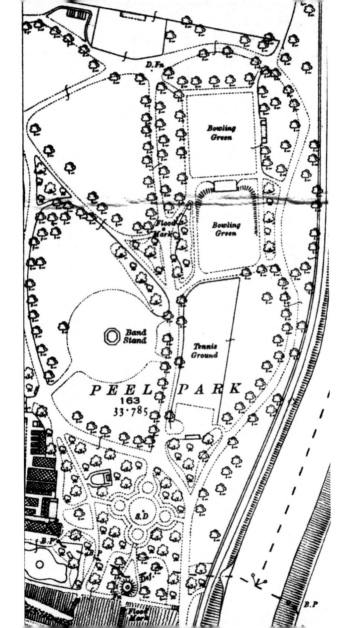

31. PEEL PARK

A general view of the park taken in 1926.

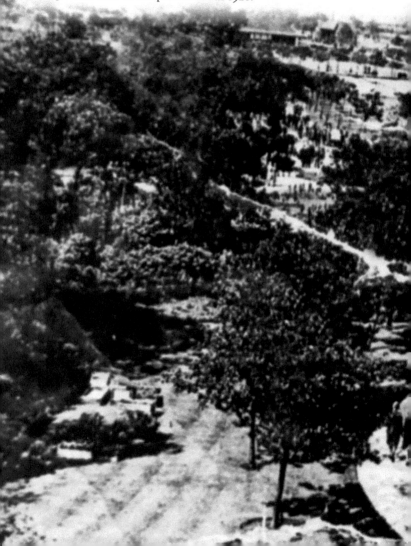

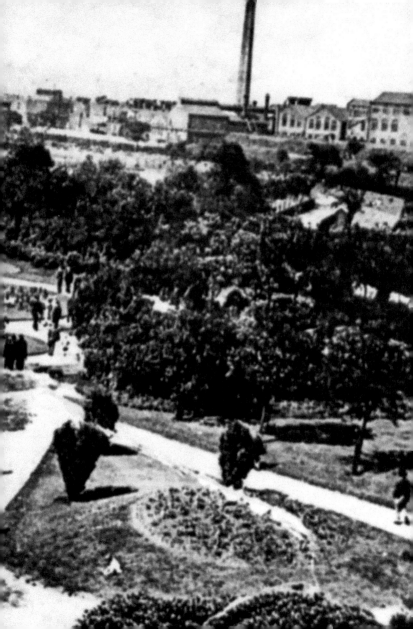

32. PEEL PARK

Peel Park's lake, like so many others in Salford, was filled in during the mid-twentieth century. This picture was taken in 1908.

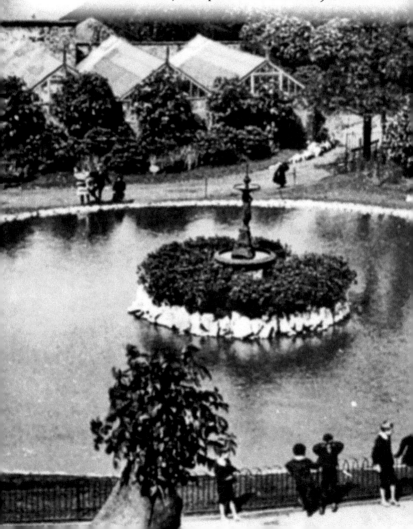

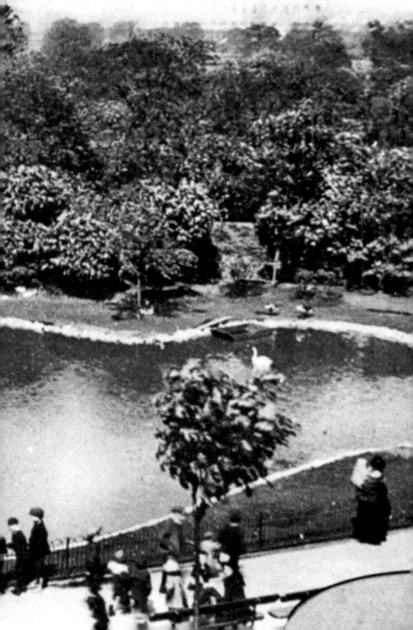

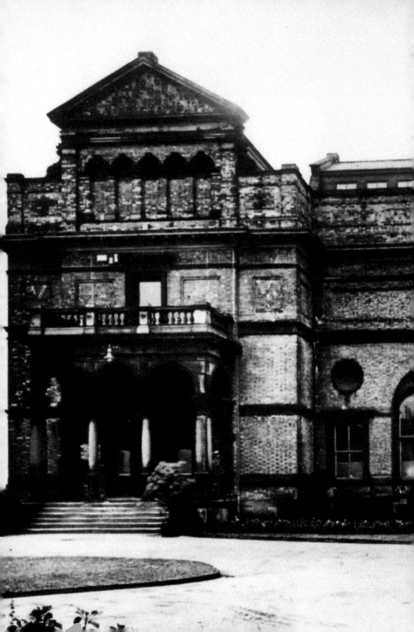

33. ART GALLERY AND MUSEUM

The museum was built in 1850 and opened the country's first free public lending library in 1851. Two wings were added by 1857 and another was added in 1936–38.

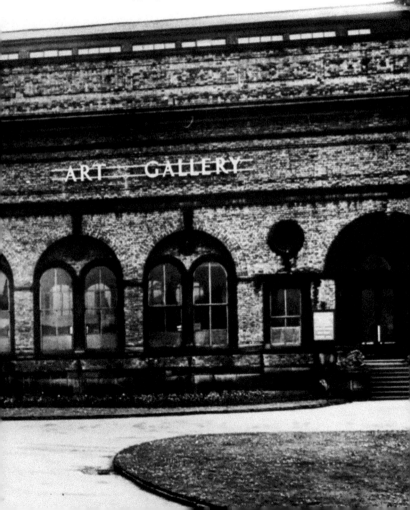

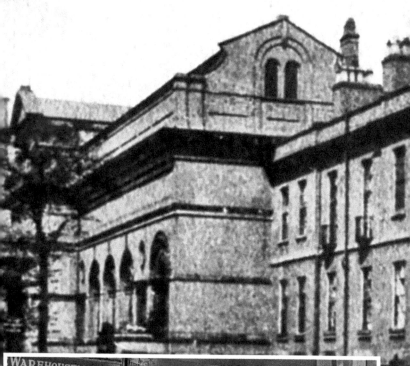

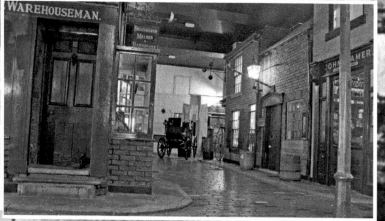

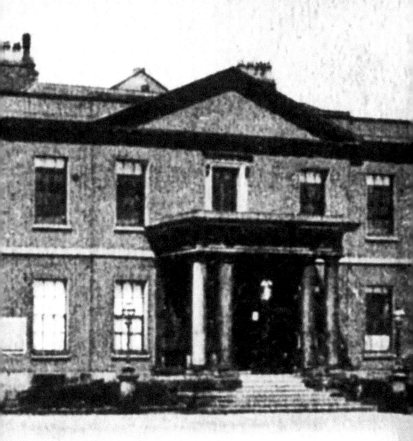

34. ART GALLERY AND MUSEUM

This building now contains an art gallery, café and the Salford Local History Library, whose collection of over 65,000 photographs was used to find the historic photographs in this volume. The inset shows the fascinating Victorian street called Lark Hill Place – named after the house that formerly stood on this site.

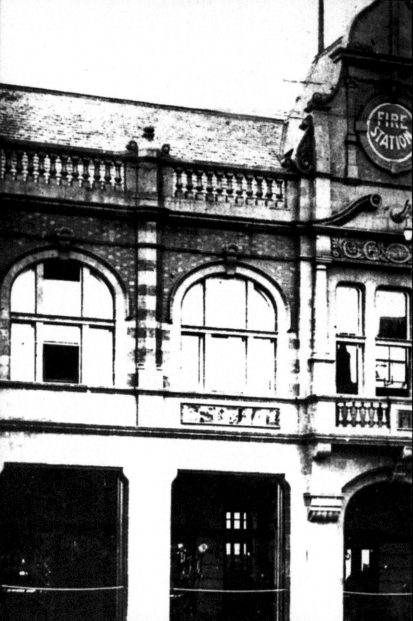

35. SALFORD FIRE STATION

The fire station was built in 1903, including firemen's houses behind. The station closed and the houses were modernised in the 1980s. The building became an art gallery and is now occupied by Salford University. Nearby is a Grade II listed red telephone kiosk.

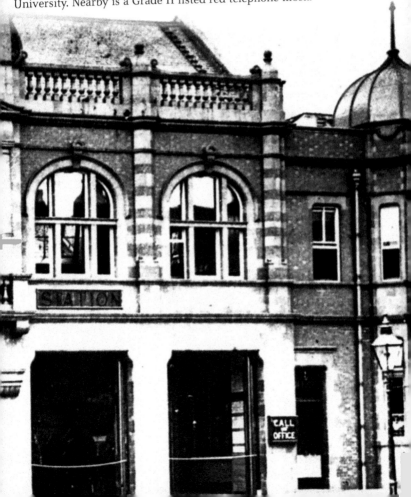

36. JOULE HOUSE

A plaque records: 'James Prescot Joule, scientist, 1818–1889, lived and worked here. A noted scientist who established the principle of the mechanical equivalent of heat. His name has been given to the unit of energy, the Joule.' The picture was taken in 1958, and the building is now being used by Salford University, appropriately as an energy research centre.

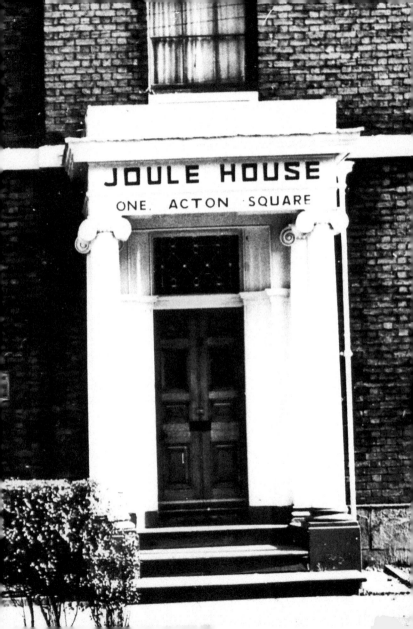

37. PEEL BUILDING

The Peel Building was built in 1896 to house the Salford Royal Technical Institute and is noted for its terracotta panels depicting craftsmen and engineers at work. Artist L. S. Lowry studied here in the 1920s and produced several sketches and paintings of the buildings and the park. The building was extensively refurbished in 1985 and it now houses the university's School of Environment and Life Sciences. The statues of Queen Victoria and Prince Albert were erected by public subscription and unveiled in 1857 and 1864 respectively. The gazebo-like structure closer to the Peel Building was originally part of the building's ventilation system. Both the gazebo and the Peel Building are Grade II listed buildings.

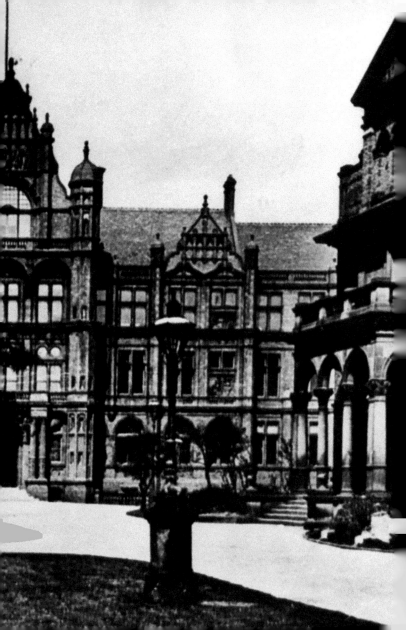

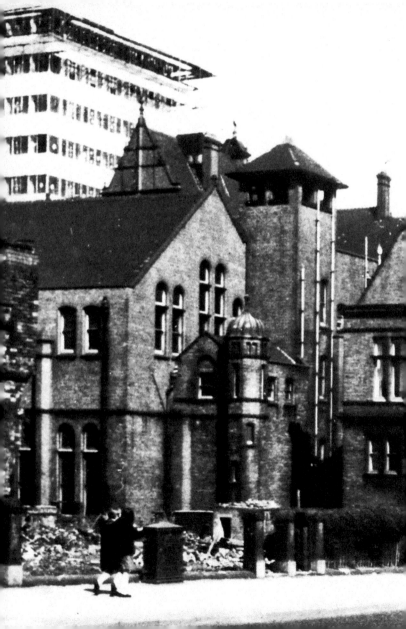

38. PEEL BUILDING

This picture shows the back of the Peel Building with the former tower block beyond, built in the 1960s between it and the art gallery, on the condition that the Peel Building was demolished! Happily it was the tower block that was demolished in 1994.

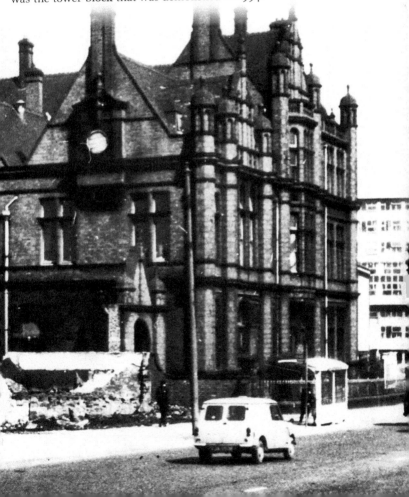

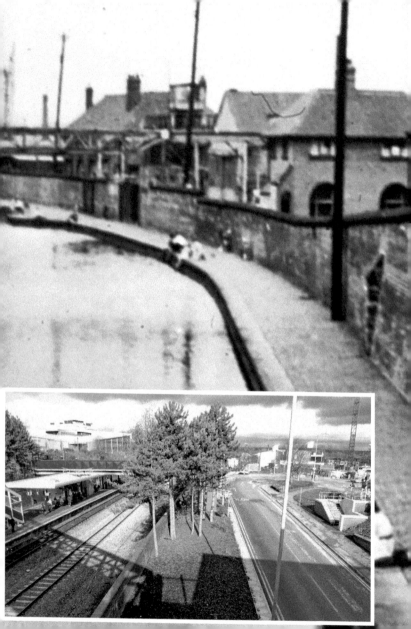

39. WINDSOR BRIDGE

The scene in the main picture taken from Windsor Bridge is now unrecognisable. The inset is taken from a similar spot, just outside the new booking hall of Salford Crescent Station. When restored, the canal will pass beneath the booking hall, and go along the line of the earth bank between the railway track and the road.

40. BROAD STREET

The main picture was taken in 1914. Originally called New Richmond and Paddington, Broad Street always lived up to its name, but the widening of the A6 in the 1960s virtually trebled its width, and many European-style high-rise flats were built.

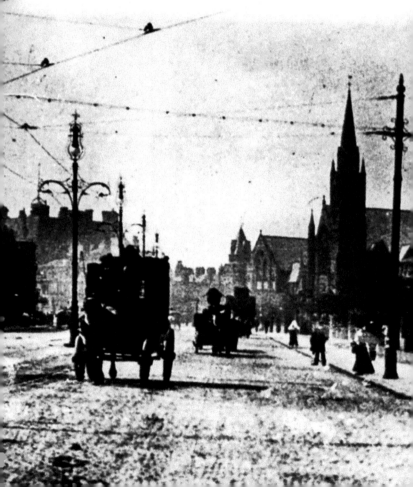

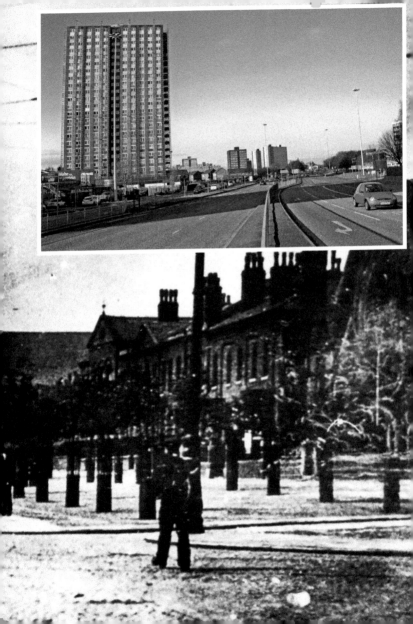

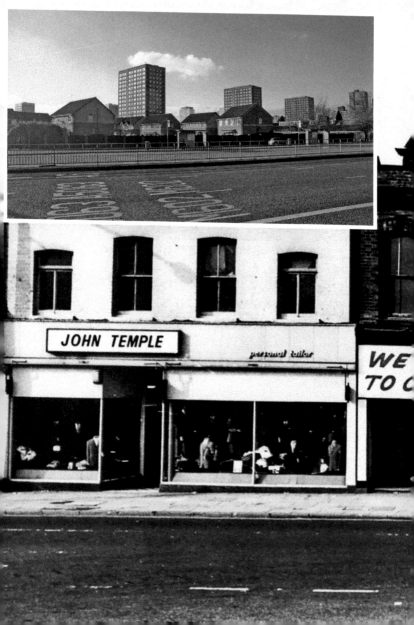

41. BROAD STREET

The area on the south-east side of Broad Street had numerous shops, with tightly packed terraced housing behind, most of which was demolished in the late 1960s and early 1970s to make way for the flats. In the main picture one shop is already boarded up, while another anticipates demolition. Beyond the poorly designed Salford Shopping Centre was built and still survives.

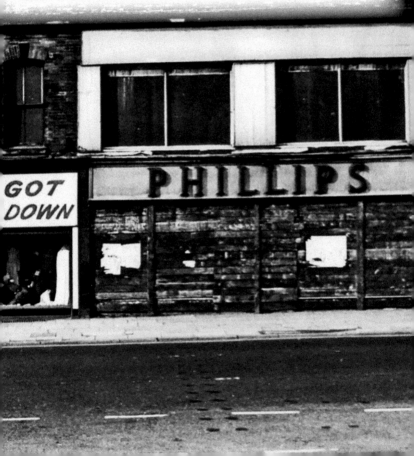

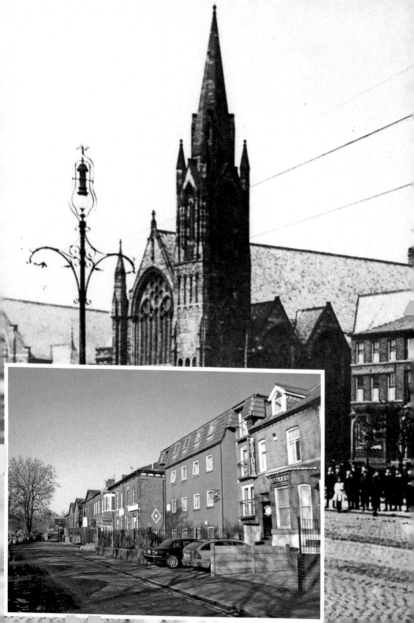

42. BROAD STREET

The north-east side of Broad Street once boasted five chapels and churches (three of them Methodist), but only the Wesleyan Methodist School building survives, and is no longer in religious use. One block of terraced housing remains.

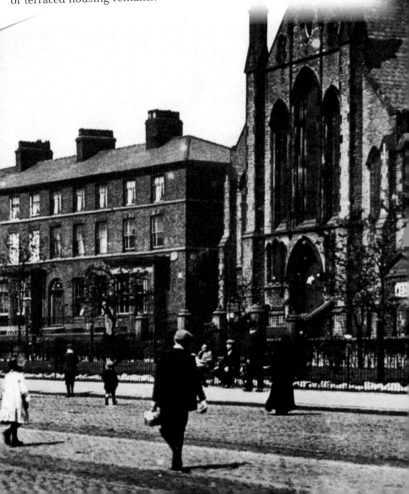

43. PENDLETON

Pendleton was independent of Salford until 1853, having its own Town Hall. The shops on the left were demolished to make way for an underpass, which was opened in 1968. St Thomas's Church was consecrated in 1831 and is almost the sole surviving feature of old Pendleton. The town once had two railway stations, the old station opened in 1843 and the New station in 1883.

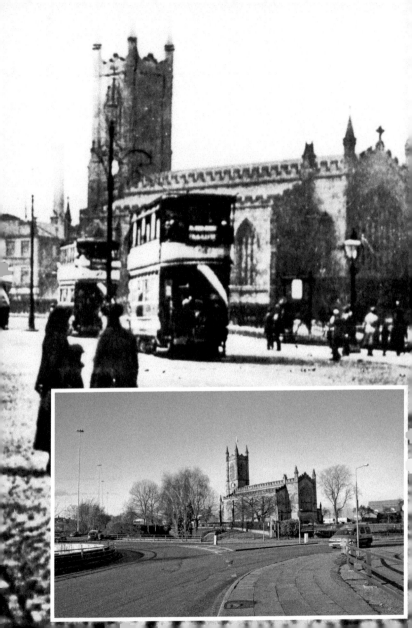

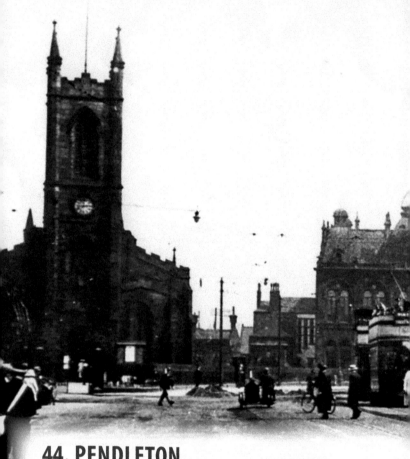

44. PENDLETON

The main picture was taken in 1930. Looking back towards Salford, St Thomas's Church survives, but the Town Hall and shops have been replaced by roads. The inset shows the original Broad Street on the left, while the road on the right is merely a slip road from the A6 before it goes into the underpass.

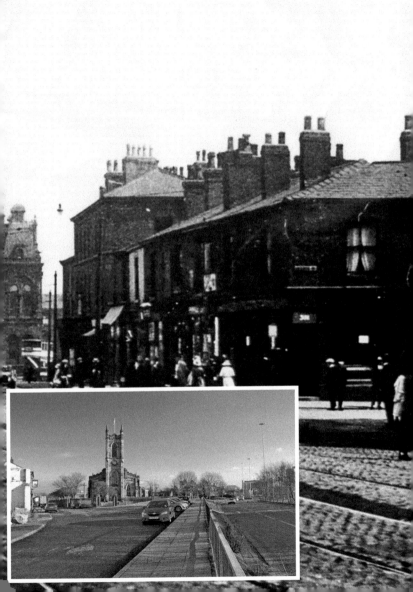

ABOUT THE AUTHOR

After taking (very) early retirement from being a senior lecturer in Geography at Salford University, Paul now concentrates on researching, writing and lecturing in various fields of historical geography. His main academic interests are historic maps, roads, canals, and the Lake District. Other interests include limestone landscapes and caves, and towns and roads in medieval England.

He has written several books, including:

- *Maps for Historians* (Phillimore, 1998)
- *Roads and Tracks of the Lake District* (Cicerone, 1998, 2011)
- *Roads and Tracks for Historians* (Phillimore, 2001)
- *Medieval Town Plans* (Shire, 1990–2011)
- *Medieval Roads & Tracks* (Shire, 1982–2016)

He has written three books in the Through Time series:

- *Manchester Bolton & Bury Canal Through Time* (Amberley, 2013)
- *Salford Through Time* (Amberley, 2014)
- *Salford Quays Through Time* (Amberley, 2017)

He has also written commentaries for reproductions of numerous maps in the Godfrey edition of early Ordnance Survey maps.

He is editor of *North West Geography*, the e-journal of the Manchester Geographical Society, of which he is honorary secretary (www.mangeogsoc.org.uk).

He is chairman and editor of the Manchester Bolton & Bury Canal Society (www.mbbcs.org.uk).